JOAN MIRÓ
Sculpture

Southampton City Art Gallery
8 December 1989 – 14 January 1990

Ikon Gallery Birmingham
20 January – 24 February 1990

Aberdeen Art Gallery
10 March – 8 April 1990

A SOUTH BANK CENTRE TOURING EXHIBITION

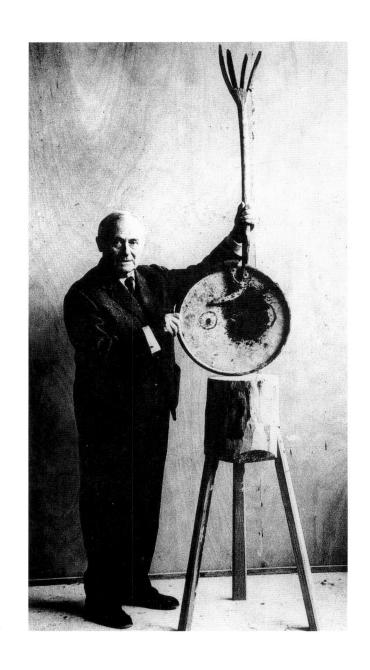

Miró holding *Personage, 1967*
© C. Gaspari

2

Contents

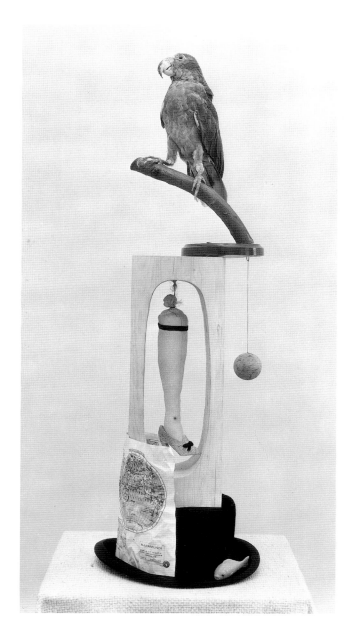

Object, 1936
Assemblage: stuffed parrot on wood perch,
stuffed silk stocking with velvet garter
and doll's paper shoe suspended in hollow
wood frame, derby hat, hanging cork ball,
celluloid fish, and engraved map
The Museum of Modern Art, New York
Gift of Mr and Mrs Pierre Matisse
(not in exhibition)

Preface

Joan Miró produced paintings, murals, prints, costume designs, poetry, sculpture and ceramics and excelled in each of these activities. Apart from Picasso, his fellow countryman, no other artist in the 20th century has shown such versatility and invention across so wide a range of media.

This exhibition is concerned with one part of one area of Miró's work. It comprises thirty-seven sculptures made over the last forty years of his life. All are bronzes, his early assemblages being too fragile to travel extensively and most are comparatively small: Miró distinguished his 'monumental' projects from the more private activity of making 'sculptures'.

In their dream-like combination of objects and images the sculptures speak of Miró's earlier involvement with Surrealism, but their roots are in the natural landscape of his native Catalunya and Mallorca. It is his search for the extraordinary in the ordinary, mundane objects that he assembled and cast which underlies his sculptural process.

The exhibition has been made possible by the generosity of three organisations. The Fundació Joan Miró in Barcelona and the Fabian Carlsson Gallery in London have lent the sculptures. The Henry Moore Foundation has provided financial support. We express our warmest thanks to them.

The introductory essay to this catalogue is by William Jeffett whose research was in part funded by the Central Research Fund of the University of London.

JOANNA DREW
Director, Hayward and Regional Exhibitions

ALEXANDRA NOBLE
Exhibition Organiser

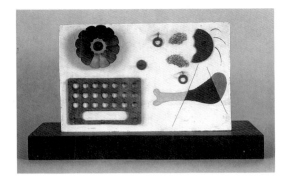

Painting-Object, 1931. Painted assemblage on wood
Kunsthaus, Zurich. Donation E. & C. Burgauer
(not in exhibition)

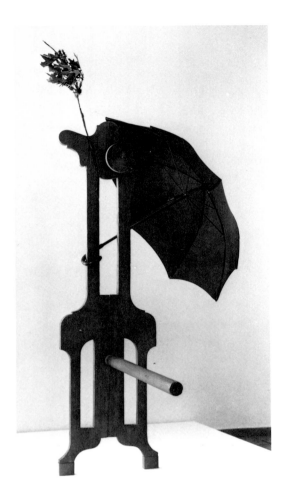

Figure, 1930. Wood, artificial flowers and umbrella
Joan Miró Foundation, Barcelona
(not in exhibition)

Joan Miró's Vagabond Sculpture

Joan Miró (1893 – 1983) was initially trained in his native Barcelona, where he attended L'Escola de Belles Artes La Llotja and the artistically progressive Escola d'Art directed by Francesc D'A. Galí Fabra. Later Miró recalled the unorthodox teaching techniques which Galí employed: *"Galí was a remarkable teacher, and he gave me an exercise so that I would learn to 'see' form: He blindfolded me, and placed objects in my hands, then he asked me to draw the objects without having seen them. So my interest in sculpture actually dates from that time ..."* [1]. Shortly thereafter, at the insistence of his family, Miró worked as a book-keeper and within a few months he had a minor nervous breakdown and fell ill. To assist his recovery, his family bought a small farm near Montroig in the region of Tarragona, south of Barcelona on the Mediterranean coast. There Miró gathered things he found during his walking excursions through the countryside. While these small, found objects do not constitute sculpture in themselves, they were Miró's earliest contact with the idea of sculpture.

Miró's first sculptures grew out of and were created in opposition to painting. He called for the *"murder of painting"*, a phrase he frequently used between 1926 and 1934 [2]. Miró had arrived in Paris in March 1920, at the height of the Dada provocations organised by Tristan Tzara and Francis Picabia. He embraced their anti-artistic position, and he was a central participant in André Breton's Surrealist movement from about 1922 onwards. His studio at 45, rue Blomet, adjacent to that of André Masson, became a meeting place for a brilliant group of young writers: Michel Leiris, Antonin Artaud, Armand Salacrou, Georges Limbour and Robert Desnos along with the two painters. In 1928 and 1929 Miró began exploring collage which prefigured his relief constructions of the following summer. In 1931 he extended painting into relief by assembling otherwise insignificant objects which were then painted, thereby transforming them into figures. These first 'sculptural' works were included in the numerous Surrealist exhibitions which began to proliferate in the first years of the 1930s. Perhaps the most humorous of these sculptures is the large *Figure* made in the summer of 1930, with its giant phallus. Breton included this sculpture in the 1933 Salon des Surindépendants, where it caused a scandal.

In the 1930s the Surrealists turned their attention to the development of the 'symbolic object', in which the arrangement of incongruous things was designed to elicit a disturbing response and trigger an awareness of long repressed experiences and sexual memories. In

short, the 'surrealist object' was a physical equivalent of Sigmund Freud's explorations in psychology, and its goal was the liberation of the viewer's desires [3]. Miró contributed to this activity by making two sculptures: *Objet du Couchant* (1936; Centre Georges Pompidou, Paris) in which the use of a tree trunk and bits of rusting iron became metaphors for the sexual union of man and woman, and *Objet* (1936; Museum of Modern Art, New York) in which a stuffed parrot, a bowler hat and what appears to be a woman's leg clad in silk stockings, a garter and a high-heeled shoe become emblems of the masculine dream world. The first was probably exhibited in the Exhibition of Surrealist Objects at the Galerie Charles Ratton in 1936 [4].

The affinities between the Surrealist period and his later work are striking when one considers Miró's consistent use of imagery. For example, while more than three decades separate *Objet du Couchant* (1936) and *Bird's Nest on the Fingers in Bloom* (1969), and while the materials of found objects and bronze differ dramatically, both sculptures find their point of departure in the central armature of a tree trunk. One is a real tree trunk, whilst the other is a cast replica but no less real within the poetic universe of the sculptor. In the first, paint is applied to the surface of the trunk; in the second, the rough-hewn surface serves to unify the disparate objects. The innate identity of the found objects composing the sculpture are

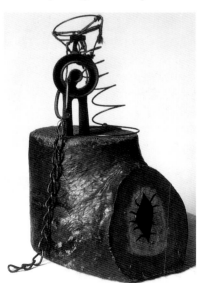

Objet du Couchant, c. 1936
Painted carob trunk and metal parts
ex-collection André Breton,
Centre Georges Pompidou, Paris
(not in exhibition)

8

transformed; they are reclaimed as living beings.

While his later bronze sculptures can no longer strictly be described as Surrealist, they do preserve something of the spirit of that movement. Unlike the other Surrealists, Miró situated the source of inspiration outside himself, in nature. The experience he expressed was that of receptive wakefulness, rather than of sleeping; the daydream rather than the nightmare. Miró never defected from the ranks of Surrealism, but he chose to follow his own solitary path in the relative isolation of rural Spain.

Miró was a sculptor who proceeded by haphazard wanderings. He was a nomad, who gathered as he walked. The range of objects included the man-made, the discarded, the natural, and the found from rural and urban terrains. They were weathered, decaying and above all fragile, encompassing the machine-made and the crafted, with a preference for tools or objects made by indigenous workmen. His paths led through the landscape of rural Tarragona and the hills of Mallorca, but also through the streets of Paris and Barcelona. Sometimes, Miró borrowed the foundry workers' tools; anything was subject to inclusion in a sculpture. The very act of wandering was a kind of play, an embracing of the aimless, or in the words of Tristan Tzara, *"non-directed"* [5] thought, in which the receptivity of the painter opened into the presence of nature, into the life of things. But more than this, wandering was an opening on to creativity, not understood as mere technique, but rather as profoundly felt material inspiration.

Throughout his life Miró spent an increasing amount of time in rural Catalunya and Mallorca, and he drew on this culture of peasant craft, founded on an economy of wine and olive oil, as a source for sculpture. Miró's view was organic and vitalist: because he thought of himself as rooted in the Catalan countryside, the activity of sculpture was intimately bound up with nature.

Miró always chose to make sculpture either at his farm in Montroig or at his studio near Palma, in Cala Mayor. Whilst he was working on his first sculptures, Miró started modelling in clay, undoubtedly as a result of his collaboration with the ceramicist Josep Llorens Artigas (1892 – 1980). The earliest bronzes such as *Lunar Bird* (1946 – 1949) and *Woman* (1949) employed the traditional lost wax technique and the conventional dark, classically-inspired patina typical of much bronze sculpture. *Lunar Bird* established the use of a symbolic imagery of horizontal and vertical, night and day, male and female, as is evident in its pendant piece, *Solar Bird* (1946 – 1949; not in this exhibition). *Lunar Bird* relates to the terracotta sculptures which Miró made during the same years, but while *Lunar Bird* was conceived specifically as a bronze,

the much later bronze *Woman* (1967) developed directly out of an earlier ceramic sculpture which Miró had made in collaboration with Artigas in 1956. The bronzes cast from figures achieved through clay modelling were indebted to Miró's fascination with the folk ceramics of Mallorca and Catalunya, most notably the polychromatic *siurells* (whistles made in terra-cotta).

Several sculptures in this exhibition incorporate everyday objects and peasant tools. *Windclock* (1967), by virtue of its construction and rough finish retains a proximity to the pre-industrial world tied to the earth for its sustenance. If it is the wind which records the passing of time, *Windclock* functions more as a weather vane, even a sun dial, than a mechanical clock. Time is marked by the natural events of atmospheric change; it is the ebb and flow of the seasons, the alternation between light and dark and the silent blowing of the wind. One is reminded of the giant, arrow-shaped weather vanes characteristic of the fantastic windmills of Mallorca. *Figure* (1967) includes a typical Mallorcan tripod, the cover of an oil drum and a hand-carved pitchfork. Its legs replace the base of traditional sculpture, and it seems to stand almost like a living being.

The imagery of his later sculptures was often that of woman and child, and he always associated sexuality with both fecundity and the cycles of nature. In *Seated Woman and Child* (1967), the chair might be understood as the architecture of the female body, an architecture which envelops the organic stone-child. The haphazard meeting of a crate, a wooden bowl and an egg in *Woman* (1969) sufficed to suggest female fertility. Gourds were used as the womb-like body of the sculpture *Maternity* (1969) and as the torso of the whimsical *Tightrope Walker* (1969).

Miró's connection with nature was neither a retreat from the modern world, nor a reaffirmation of traditional values. His frank presentation or eroticism in organic form was a call for sexual liberation and an attack on the moral hypocrisy of established values. The familiarity of the objects introduced a measure of humour into his sculptures, because even the most ordinary thing was endowed with a potential sexual meaning.

Further clues to Miró's thinking about sculpture are found in his notebooks which he wrote during 1940 – 1942. There he set out his plans, distinguishing his own projects from those of Julio Gonzàlez and Pablo Picasso, both of whom explored welding and relief con-struction. It was precisely this sculptural quality he sought to avoid, because he was more interested in *"nature"*, *"collage"*, a *"phantasmagoric world of living monsters"* and the *"magic spark"* of pure creativity:

"When sculpting, start from the objects I collect, just as I make use of the stains on paper and imperfections in a canvas – do this here in the country in a way that is really alive, in touch with the elements of nature … make a cast of these objects and work on it like Gonzàlez does, until the object no longer exists but becomes a sculpture, but not like Picasso – do it like a collage *of various elements – the objects I have in Barcelona will not continue to exist as such but will become sculptures … It is in sculpture that I will create a truly phantasmagoric world of living monsters; what I do in painting is more conventional … Use things found by divine chance: bits of metal, stone, etc., the way I use schematic signs drawn at random on the paper or an accident … that is the only thing – this magic spark – that counts in art …"* [6] His words perfectly describe the bronzes which he was to make in the 1960s and 1970s.

Again in Miró's 1941 notebook there is a curious remark, one which appears alongside those referring to bronze casting: *"… with only rare exceptions it would be a great mistake to cast my sculptures in metal; that would be the work of a sculptor, a* specialist" [7]. Given that Miró began to work in bronze shortly after he wrote this, it is instructive to ask why he chose to do so. In Jacques Dupin's words, *"Why choose bronze? Why this ungrateful material, which hides its fatigue and wear so inadequately?"* [8]. Initially Miró distrusted bronze and the specialised work of the sculptor, because he felt they were indicative of destructive individualism. Perhaps Miró's

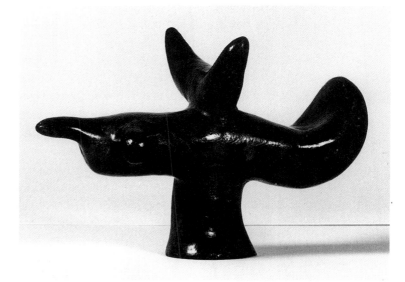

Solar Bird, 1944–1946
bronze
Joan Miró Foundation, Barcelona
(not in exhibition)

reticence toward the medium arose from an aversion to the expense entailed in casting and the implication that sculpture was a luxury. Until the 1960s Miró did not use the idea of the found object assemblage in bronze. Dupin has indicated the irony in this choice: "*The discarded object is a subject on an equal footing with that of the traditional statue, and the crushed can of sardines, as long as it is cast in bronze, has the right of abode in the Museum and contributes to 'Culture'*" [9]. Whilst bronze sculpture affirms that authority of established 'culture', its use to preserve rubbish subverts the precepts of that culture.

For Miró almost all media involved a self-consciousness with regard to technical process. Miró thought of the sculpture as merely the product of a poetic encounter, and he sought to preserve this initial experience, or what he called "*shock*", in the final work. Miró described the creative process as three-tiered: "*… three stages – first, the suggestion, usually from the material; second, the conscious organisation of these forms; and third, the compositional enrichment*" [10]. This quotation dates from 1948, but in 1937, soon after his first 'surrealist objects', the Catalan writer and art critic Sebastià Gasch had already observed a similar pattern in his paintings: "*Miró first discovers spiritual splendour in a real thing. He then appropriates this thing, fixes it in his mind, works on it, polishes it, deforms it, transfigures it, so as to incorporate it in his own works, all of it resplendent with that spirit that hides behind material appearances, and that the artist has presented, or rather has intuited, concealed within the material thing before starting his work*" [11]. For Miró, sculpture was a process of discovery and exploration; each bronze was merely a step along the path to poetic revelation.

In *The Escape Ladder* (1971) Miró returned to a recurrent preoccupation. Ladders appeared first in his paintings of the 1920s [12] and again in 1940 – 41 series of gouaches *Constellations*, which Miró painted during and immediately after his flight from the German invasion of France. In the bronze version of the *The Escape Ladder*, Miró uses an animal bone which rests on top of a stone. Above the bone is the ladder leading into the air, surmounted by a small ovoid shape, which resembles an eye. This interpretation is confirmed in a drawing for this sculpture; it bears the inscription, "*eye which escapes*" [13]. The disembodied eye is the eye of pure vision, an eye detached from everything except the escape ladder reminiscent of the optic nerve. It is also the eye of the poet which sees images rather than words. As in the case of Miró's earlier pictorial use of this image, the ladder is symbolic of an escape from earth. And while the sculpture is rooted and bounded by the earth, its base being a rock, all of its movement is vertical toward the celestial realm of pure poetic sight. Miró does not propose an opposition but a merging of the two spheres: earth and sky, below and above, matter and spirit. This

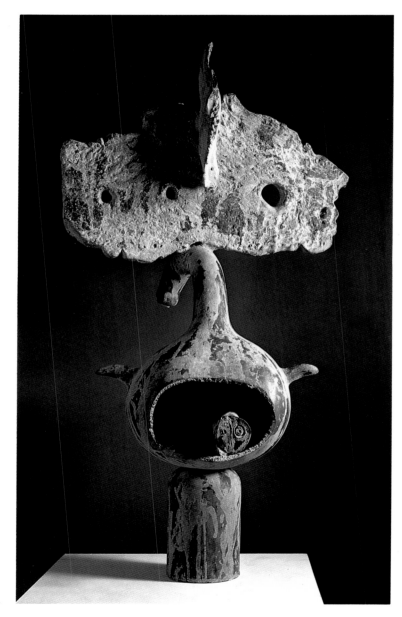

Maternity, 1969
Cat no 23
Joan Miró Foundation, Barcelona

substitution is a poetical device: the eye is an emblem of sight rather than an allusion to it. As in his first assemblages of painted objects this sculpture seems to emerge from painting.

The Escape Ladder (1971) bears comparison with the bronze sculpture Silent Constellation (1970), and if the imagery of the former suggests a striving for the heavens, the latter is a three-dimensional embodiment of the cosmic imagery first explored in Constellations. Silent Constellation is a double-sided relief sculpture with a traditional, uniformly dark green patina, and a finished surface texture. The spheres attached to the front are the constellations, as is the drawing incised into the surface; the two types of image parallel the use of transparent and overlapping figures in Miró's schematic drawings and paintings of the 1940s. On top of the relief is a crescent moon, and an egg-like sun. The Sun and Moon are symbols of the interdependence of opposing forces in affirming the unity of life as male and female, humanity and nature, reason and imagination, animate and inanimate. This imagery of cosmic duality appears in the majority of Miró's sculptures of the 1960s and 1970s. It can be seen in the three-tiered structure of Silent Constellation where the rough-hewn wooden base becomes the terrain of the earth, the relief becomes man's vision of unity with the universe, and the moon and sun become the primordial principle by which such a harmony might be achieved.

Miró's final series of bronzes, created at the beginning of the 1980s, are smaller in scale than the monumental pieces he worked on in the late 1970s [14]. But as in the case of the monumental sculptures, they spring from the same collage principle, and they play with shifts in scale to achieve the effect of metamorphosis. Although some of them were conceived as projects for unrealised monuments, these works recapture the playful attitude of the sculptures of the 1930s and the assemblage bronzes of the late 1960s and early 1970s, such as Figure (1972) which juxtaposes a plastic bottle with a used tube of shaving cream and the tin lid of a jar. Typical of this series are Figure (1981 – 83) and Head (1982), both of which transform the waste object into a human figure through the process of selection and association. These sculptures incorporate a crushed paper bag, a jar, a length of cord or a piece of cloth, either directly cast, or, first enlarged in a plaster intermediate stage. Miró's intervention was minimal. In 1970 he had stated, "It [my sculpture] has to do with the unlikely marriage of recognisable forms" [15]. In this final series of bronzes a poetry is achieved through the tension between the chance find and its preservation in bronze, by virtue of Miró's designation of anything as sculpture.

WILLIAM JEFFETT

FOOTNOTES

1 Dean Swanson, 'The Artist's Comments' (interview), *Miró Sculptures* (Minneapolis: Walker Art Center, 3–10–1971 to 28–11–1971), n. p.

2 See M. Raynal, *Anthologie de la peinture en France de 1906 à nos jours* (Paris: éditions Montaigne, 1927), p 34. In 1972 Alain Jouffroy wrote, *"If, contrary to what has been said, Miró never gave the title 'The Assassination of Painting' to any of his works, it is nonetheless true that this image of violence is the necessity that underlies his work"*, in Alain Jouffroy and Joan Teixidor *Miró Sculptures* (Paris: Maeght, 1973; New York: Leon Amiel, 1974), p 3.

3 See Salvador Dalí, 'Objets surréalists', *Surrealism au service de la Révolution* (Paris), no 3, pp 17 – 18.

4 Margit Rowell, 'Joan Miró' in *Musée national d'art moderne: La collection* (Paris: éditions du Centre Pompidou 1986), p 433.

5 Tristan Tzara, "Essai sur la situation de la poésie", *Surréalisme au service de la Révolution* (Paris), no.4, 1931.

6 Joan Miró, *Selected Writings and Interviews* [ed. by Margit Rowell] (London: Thames and hudson, 1986), p 175 & p 191; hereafter referred to as Rowell.

7 Joan Miró notebook dated July 1941 in Rowell, p 175.

8 Jacques Dupin, *Miró Sculpteur* (Barcelona: ediciones Poligrafia, 1972), p 21.

9 ibid., p 22.

10 Miró quoted in James Johnson Sweeney, 'Joan Miró Comment and Interview', *Partisan Review* (New York) v. 15, no. 2, February 1948, p 212.

11 Sebastià Gasch, *La pintura catalana contemporània* (Barcelona: Commissariat de Propaganda de la Generalitat de Catalunya, 'Aspectes de l'activitat catalana 4', 1937), p 24.

12 *Catalan Landscape* (1923 – 1924; Museum of Modern Art), *The Harlequin's Carnival* (1924 – 1925; Albright-Knox Art Gallery), *Dog Barking at the Moon* (1927; Philadelphia Museum of Art).

13 Fundació Joan Miró no. 3552, 'L'oeil qui s'évade' in G. Moure, *Miró Escultor* (Madrid: Ministerio de Cultura, 1986 – 87), p 73.

14 Miró's exploration of monumental sculpture sprang from ceramics, especially in the large scale public murals which Miró began in the late 1950s, and which he continued creating until the late 1970s. The large bronzes of the 1970s are often designated as monuments. A desire to create an art available to the people lay behind these works.

15 Dean Swanson, op. cit., n. p.

"... build myself a big studio, full of sculptures that give you a tremendous feeling of entering a new world ... unlike the paintings that are turned facing the wall or images done on a flat surface, the sculptures must resemble living monsters who live in the studio – a world apart."

<div align="right">Miró, 1941</div>

"may my sculptures be confused with elements of nature, trees, rocks, roots, mountains, plants, flowers ... a studio in the middle of the countryside, very spacious, with a facade that blends into the earth ... absolutely not white, and now and then take my sculptures outdoors so they blend into the landscape."

<div align="right">Miró, 1941</div>

16

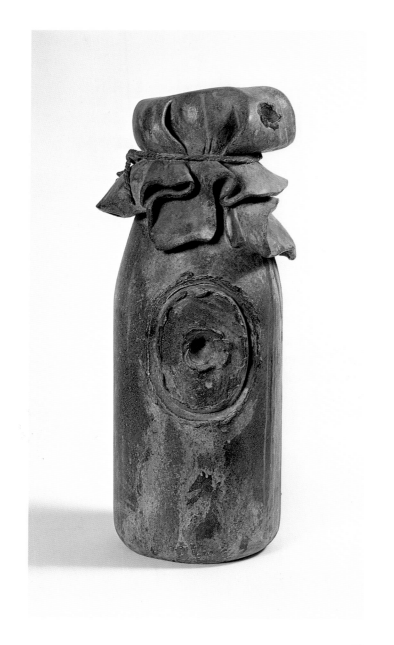

Personage, 1981–3
Cat no 37

A Note on the Technique of Bronze Casting

Almost all of Miró's later sculptures were made using the lost wax process (cire perdu), although a few were sand-cast (font au sable). Miró worked mostly with the Clémenti foundry at Arceuil, the Susse foundry at Meudon, and the Parellada foundry in Barcelona. Clémenti used the lost wax process while the Susse foundry and Parellada worked in both lost wax and sand casting; the latter is a more suitable method for larger and less complicated works.

Lost wax bronze casting, the oldest and most traditional method of making moulds, is done in the following way [1]. A segmented plaster mould is made around the model and the interior of the mould is coated with a thin layer of wax to the thickness of the bronze desired. The outer mould is then removed and can be re-used (eg., for editions). The wax replica of the artist's model is encased and filled with a fire resistant material. Wax protrusions are fitted which form the feeder, vents and channels through which the metal and hot gases pass. Nails are fitted which support the sculpture within the centre of the fire resistant mould. The encased wax is then heated in an oven causing it to evaporate. The liquid bronze is then poured into this mould to form the hollow sculpture. The fire resistant casing is then broken revealing the bronze.

Sand casting is based on the principle of a negative mould, and offers certain advantages over the lost wax process in achieving a highly polished, refined metal surface. An impression of the object is made directly into a fine, moist sand (made from a mixture of clay, silica and aluminium) packed into steel moulding boxes. Should the artist's model be large and complex, series of trays are stacked together (until the model is removed), the sand retaining the impression of the model. The pathways through which the metal and gases pass are cut into the sand. A sand core, supported by steel rods is made which becomes the interior void of the sculpture. The sand in the steel boxes is allowed to dry, sometimes by heating it in an oven. The moulds are reassembled, and liquid bronze is poured into the cavity. After the metal cools the impacted sand is knocked out of the steel boxes exposing the sculpture in its raw state.

After casting, the rough bronze is cleaned with a heavy wire brush or with a sand blaster. The surface is finished and 'chased' to remove any protruding pieces of metal, and any holes are repaired. Finally, the colour or patina is applied to the surface by the application of different acids.

Miró's choice of patina was unorthodox to say the least. In the works executed at the Clémenti foundry, he had the sculptures painted in bright colours, thereby disguising the bronze. At the Parellada foundry, Miró chose a patina which preserved the rough and varied 'fire skin', or the unfinished surface of the bronze metal as it appears when emerging from the mould. This technique produced a variegated surface pattern, green in colour, which imitated the accidental variations in surface resulting from the high temperatures reached in casting. This was a calculated effect, however, requiring as much effort on the part of the foundry artisans as more classically inspired surfaces. The sculptures Miró made at the Susse foundry are simpler in contour and larger in scale with dark, traditional patinas. The majority of Miró's sculptures were made by the lost wax method, which, although more expensive, is generally more adaptable to the artist's intentions and accurate in the production of commercial editions.

Miró often did numerous rough drawings of the found objects he assembled. They represented the actual composition of the sculpture and he then took these drawings with the objects to the foundries, where they were cast in bronze.

Miró sometimes intervened in the moulding at an initial stage to incise designs onto the surface of the wax model as a kind of writing [2]. In the *Bas Relief* (1971), one of a series of unique casts executed at the Parellada foundry, Miró similarly, exploited the sand casting technique, by drawing in the sand trays, to incorporate spontaneous designs [3]. In the sculpture *Woman* (1970) Miró used a toy doll as the starting point for the bronze, but he retained the protruding nails which are used to assure the support of the initial wax model within the refractory mould [4]. Such sculptures draw attention to the materials of bronze casting as part of the collage principle.

W.J.

1 For a discussion of bronze casting see Anthony Padovano, *The Process of Sculpture* (New York: Doubleday, 1981) and Philippe Clérin, *La sculpture, toutes les techniques* (Paris: Dessain & Tolra, 1988).

2 Dean Swanson, op. cit., 'I incise (designs) in the wax.'

3 Because Miró drew the design directly into the sand frame, which was subsequently broken, there was only one 'unique' example made.

4 See above discussion of the technique of bronze casting.

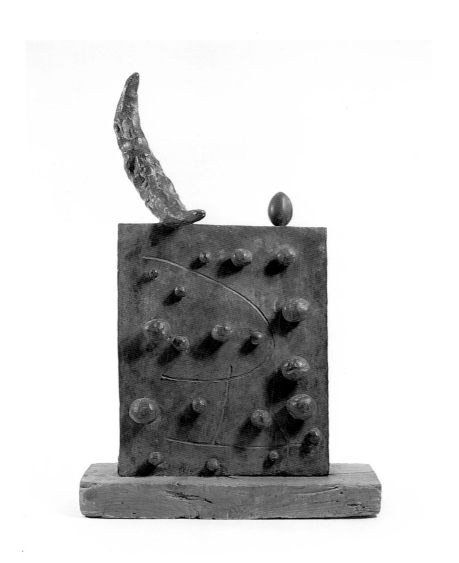

Silent Constellation, 1970
Cat no 25
Joan Miró Foundation, Barcelona

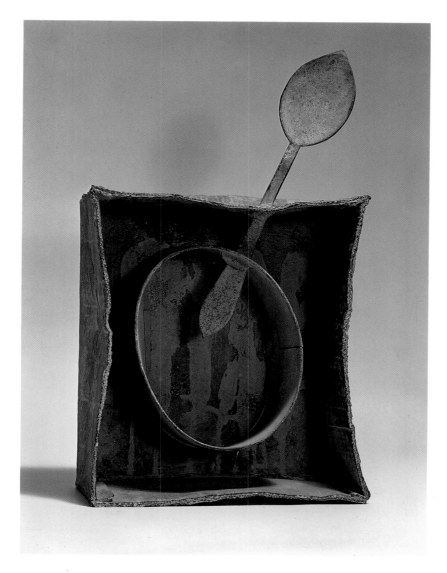

Windclock, 1967
Cat no 10
Joan Miró Foundation, Barcelona

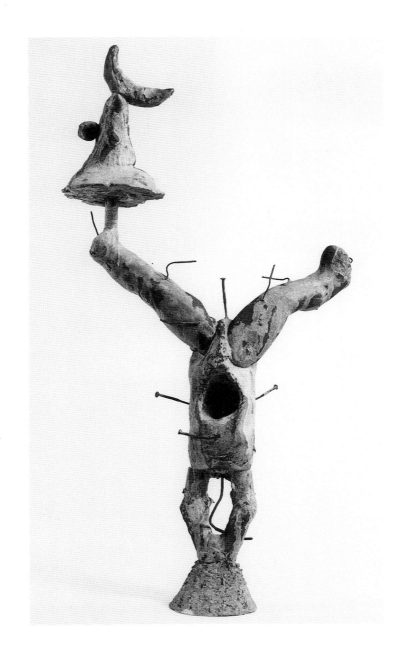

Woman, 1970
Cat no 27
Joan Miró Foundation, Barcelona

22

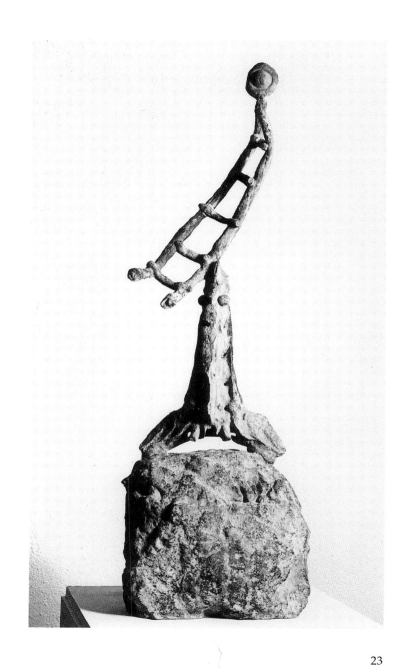

The Escape Ladder, 1971
Cat no 32
Joan Miró Foundation, Barcelona

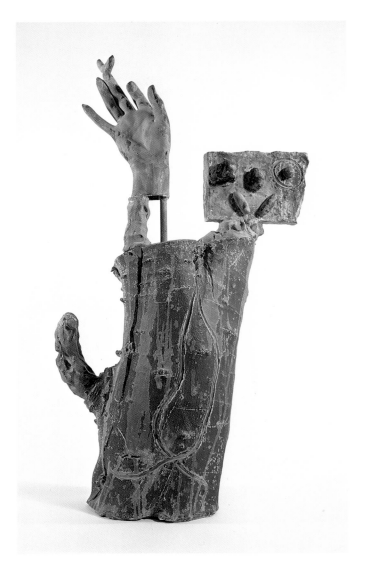

Bird's Nest on Fingers in Bloom, 1969
Cat no 19
Joan Miró Foundation, Barcelona

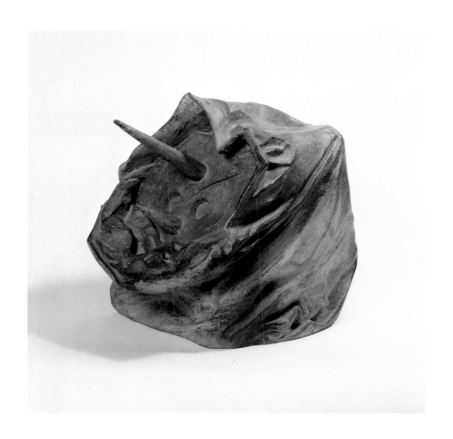

Head, 1982
Cat no 36

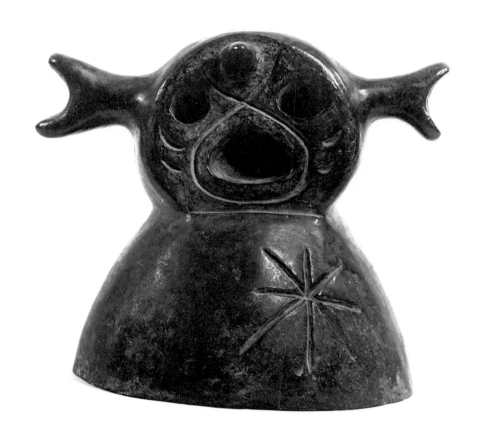

Woman, 1949
Cat no 2
Joan Miró Foundation, Barcelona

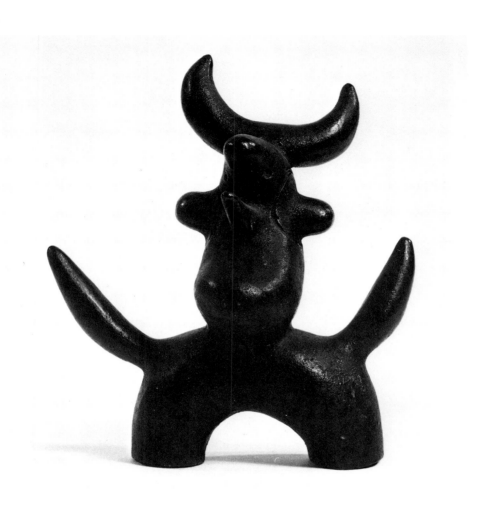

Lunar Bird, 1946–9
Cat no 1
Joan Miró Foundation, Barcelona

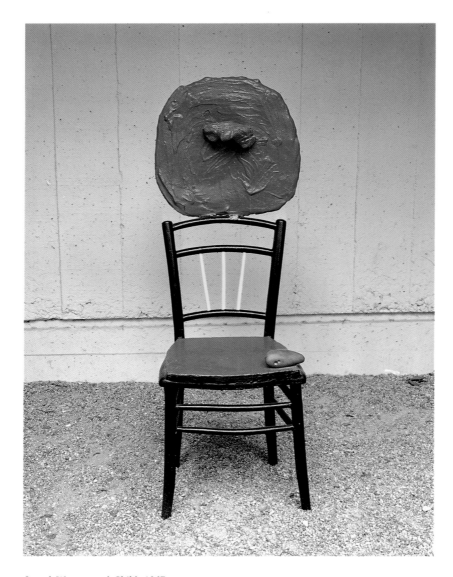

Seated Woman and Child, 1967
Cat no 12
Joan Miró Foundation, Barcelona

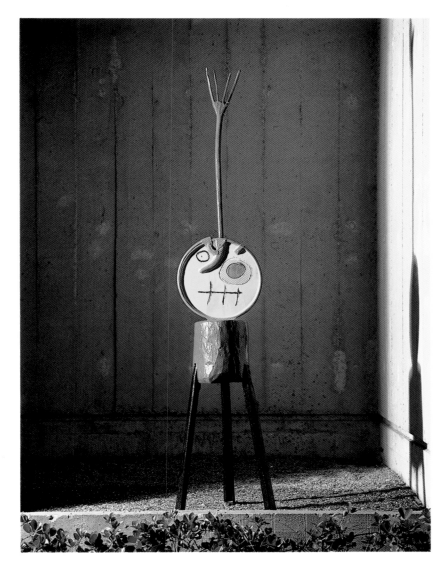

Personage, 1967
Cat no 11
Joan Miró Foundation, Barcelona

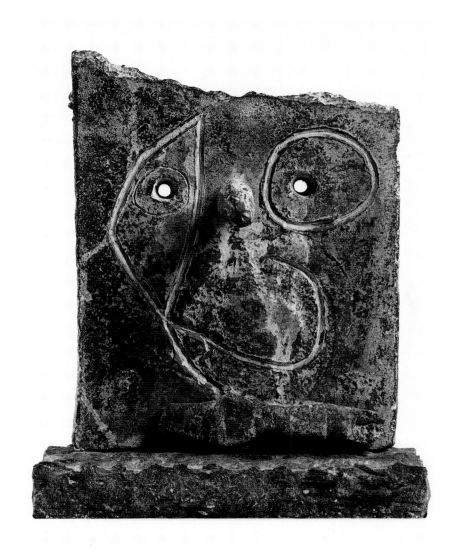

Head, 1968
Cat no 15
Joan Miró Foundation, Barcelona

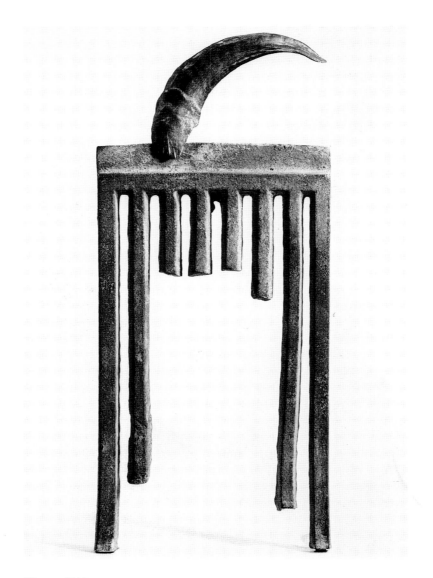

Woman, 1966
Cat no 6
Joan Miró Foundation, Barcelona

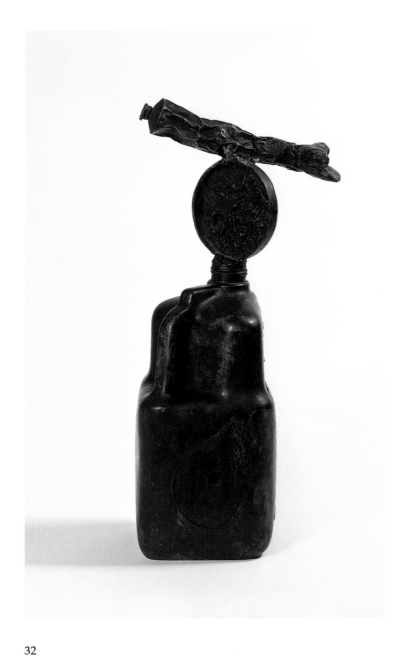

Personage, 1972
Cat no 33

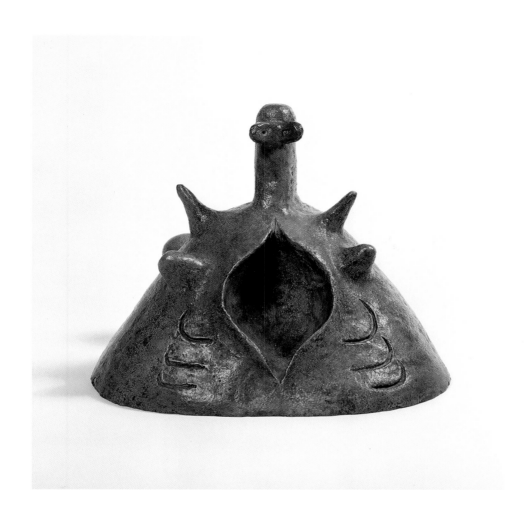

Woman, 1967
Cat no 7

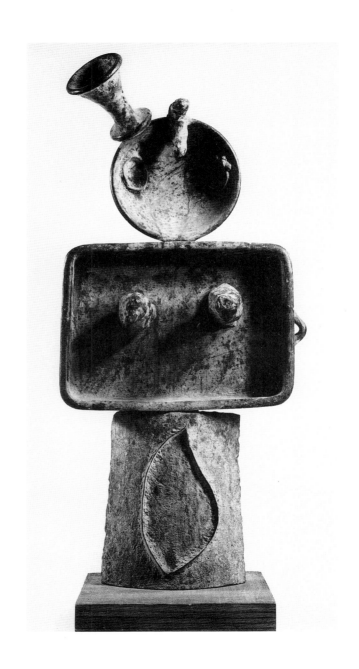

Woman, 1970
Cat no 26
Joan Miró Foundation, Barcelona

34

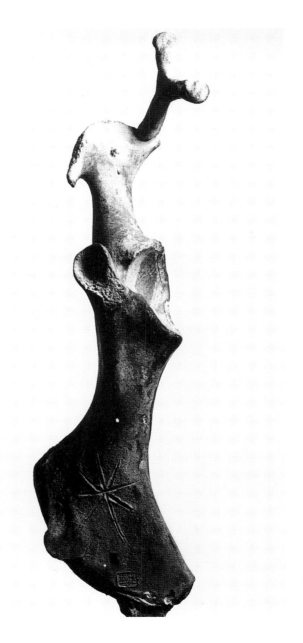

Woman, 1969
Cat no 22
Joan Miró Foundation, Barcelona

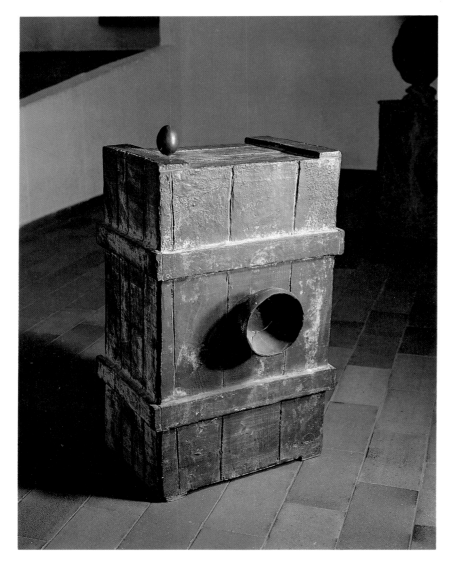

Woman, 1969
Cat no 21
Joan Miró Foundation, Barcelona

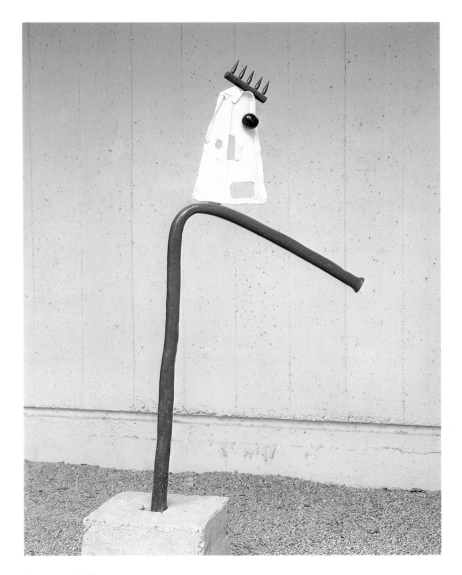

Personage, 1967
Cat no 13
Joan Miró Foundation, Barcelona

Bas relief, 1971
Cat no 31
Joan Miró Foundation, Barcelona

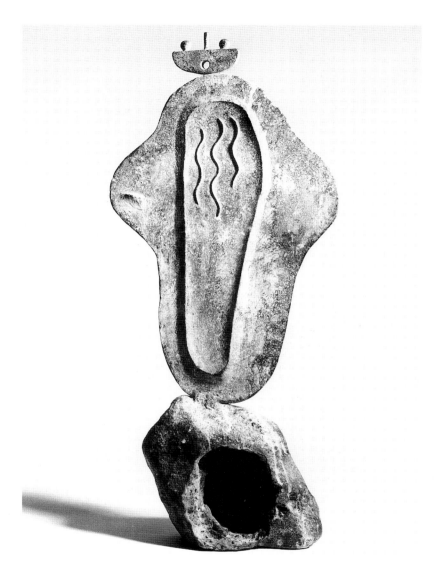

Woman in the Night, 1967
Cat no 8
Joan Miró Foundation, Barcelona

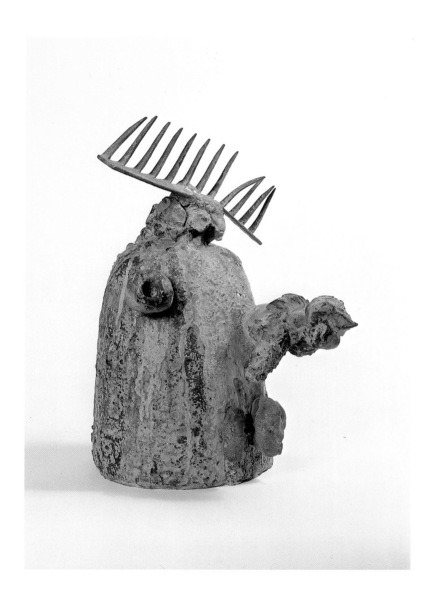

Personage, 1973
Cat no 35

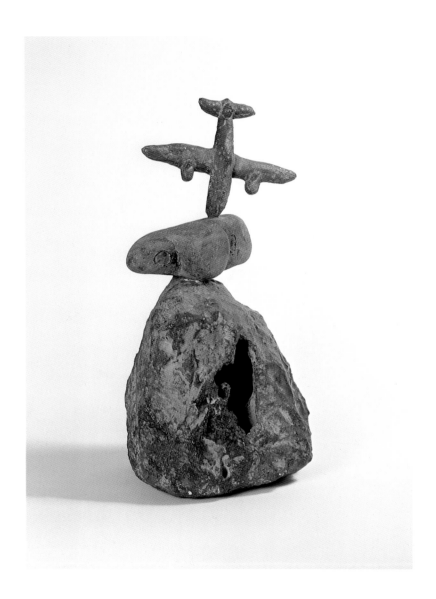

Personage and Bird, 1966
Cat no 4

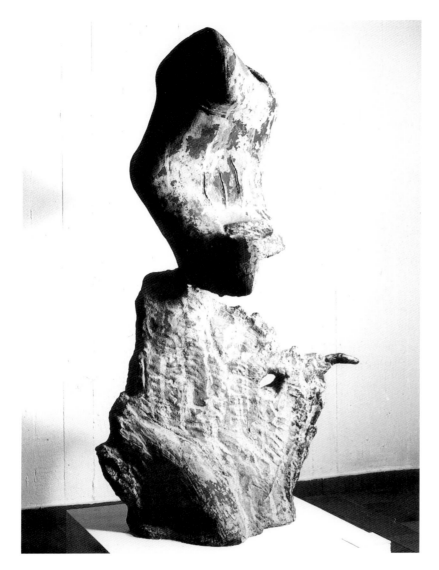

Personage, 1971
Cat no 30
Joan Miró Foundation, Barcelona

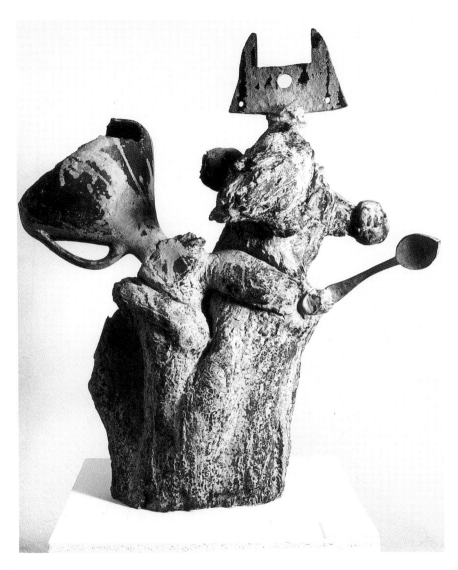

Woman Singing, 1970
Cat no 24
Joan Miró Foundation, Barcelona

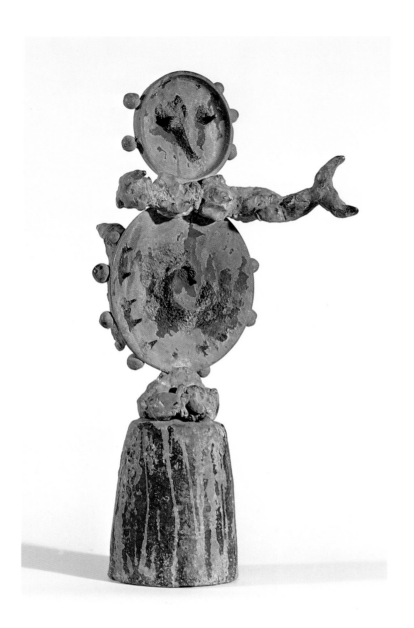

Woman, 1971
Cat no 29

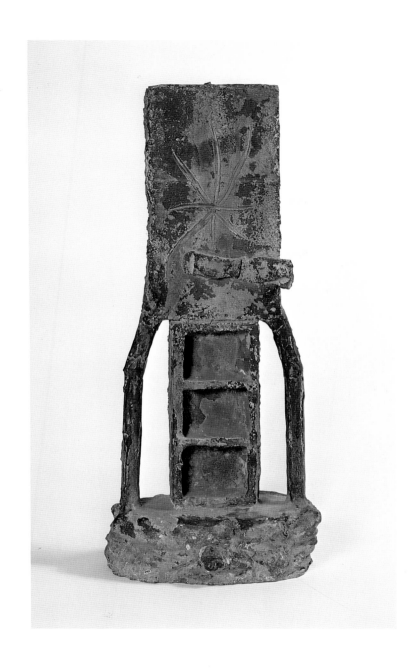

Personage, 1968
Cat no 14

45

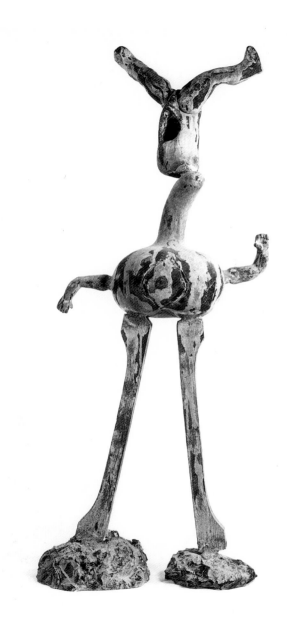

Tightrope Walker, 1969
Cat no 20
Joan Miró Foundation, Barcelona

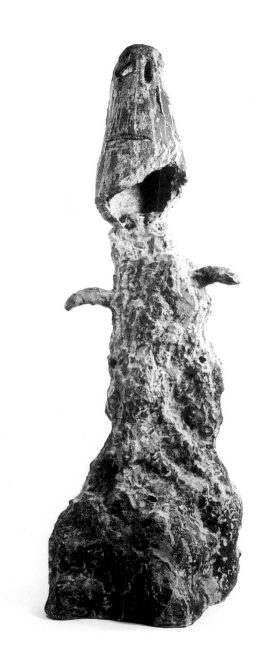

Personage, 1970
Cat no 28
Joan Miró Foundation, Barcelona

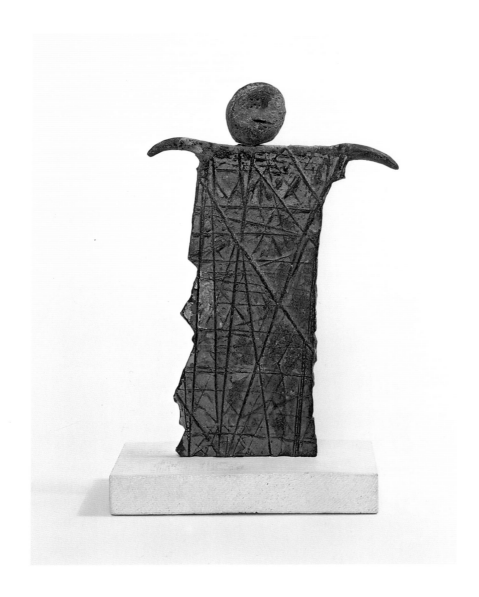

Young Woman, 1966
Cat no 3

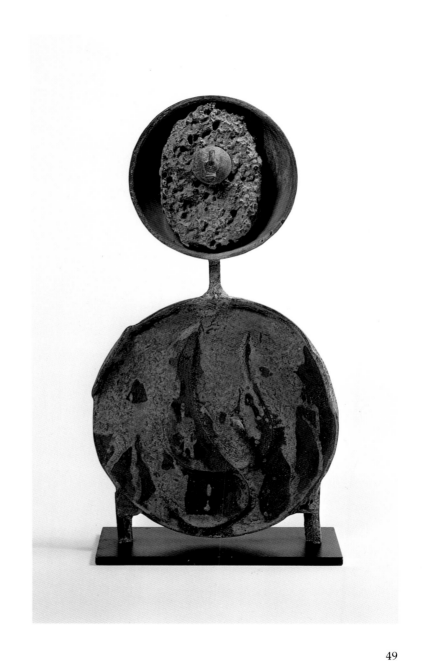

Sculpture, 1973
Cat no 34

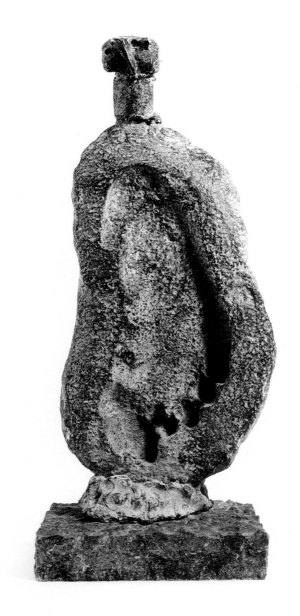

Personage, 1968
Cat no 17
Joan Miró Foundation, Barcelona

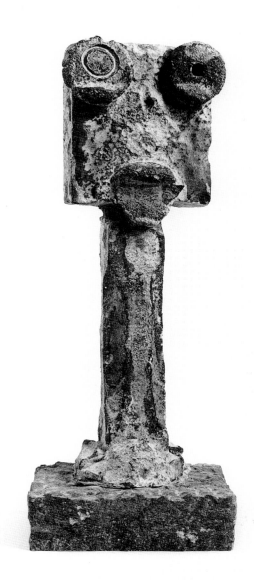

Head, 1968
Cat no 16
Joan Miró Foundation, Barcelona

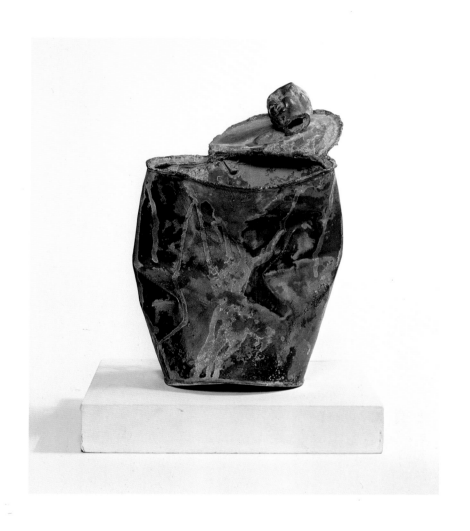

Head and Back of a Girl, 1966
Cat no 5

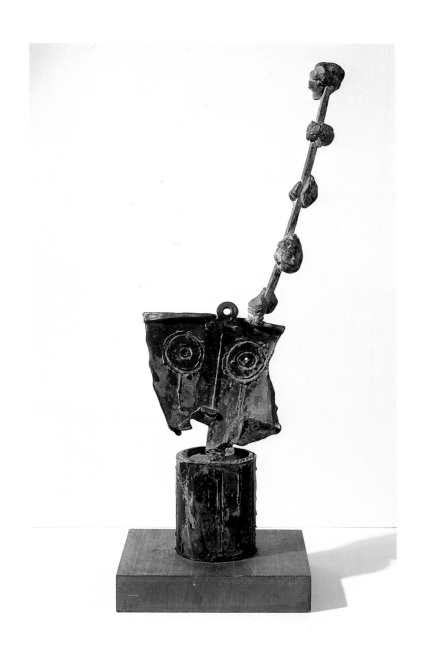

Woman, 1969
Cat no 18

Catalogue

All measurements of the bronzes are in centimetres, height x width x depth. All bronzes are unpainted unless otherwise stated. The foundries Miró used for bronze casting are also listed. Each foundry produced a different patina or finish to his sculptures.

1 *Lunar Bird, 1946 – 9*
 19 x 17 x 12.5cm
 Foundry: V Gimeno, Barcelona
 Joan Miró Foundation, Barcelona

2 *Woman, 1949*
 23.5 x 24.4 x 19.5cm
 Foundry: V Gimeno, Barcelona
 Joan Miró Foundation, Barcelona

3 *Young Woman, 1966*
 30.5 x 19.5 x 2.5cm
 Foundry: Parellada, Barcelona
 Fabian Carlsson Gallery, London

4 *Personage and Bird, 1966*
 47.5 x 26 x 20cm
 Foundry: Parellada, Barcelona
 Fabian Carlsson Gallery, London

5 *Head and Back of a Girl, 1966*
 34 x 22.5 x 19.5cm
 Foundry: Parellada, Barcelona
 Fabian Garlsson Gallery, London

6 *Woman, 1966*
 41.5 x 18 x 3.5cm
 Foundry: Parellada, Barcelona
 Joan Miró Foundation, Barcelona

7 *Woman, 1967*
 28 x 32 x 26cm
 Foundry: Susse, Paris
 Fabian Carlsson Gallery, London

8 *Woman in the Night, 1967*
 63.7 x 28 x 13.5cm
 Foundry: Parellada, Barcelona
 Joan Miró Foundation, Barcelona

9 *Personage and Bird, 1967*
 43.5 x 31 x 16cm
 Foundry: Parellada, Barcelona
 Joan Miró Foundation, Barcelona

10 *Windclock, 1967*
51 x 29.5 x 16cm
Foundry: Parellada, Barcelona
Joan Miró Foundation, Barcelona

11 *Personage, 1967*
Painted bronze
217 x 47 x 39cm
Foundry: T Clémenti, Paris
Joan Miró Foundation, Barcelona

12 *Seated Woman and Child, 1967*
Painted bronze
123 x 39 x 40cm
Foundry: T Clémenti, Paris
Joan Miró Foundation, Barcelona

13 *Personage, 1967*
Painted bronze
159 x 82 x 30cm
Foundry: T Clémenti, Paris
Joan Miró Foundation, Barcelona

14 *Personage, 1968*
58.5 x 26 x 18cm
Foundry: Parellada, Barcelona
Fabian Carlsson Gallery, London

15 *Head, 1968*
28 x 22 x 9.5cm
Foundry: Parellada, Barcelona
Joan Miró Foundation, Barcelona

16 *Head, 1968*
34 x 12 x 9cm
Foundry: Parellada, Barcelona
Joan Miró Foundation, Barcelona

17 *Personage, 1968*
43.5 x 19 x 11cm
Foundry: Parellada, Barcelona
Joan Miró Foundation, Barcelona

18 *Woman, 1969*
69 x 19.5 x 11cm
Foundry: Parellada, Barcelona
Fabian Carlsson Gallery, London

19 *Bird's Nest on Fingers in Bloom, 1969*
80.5 x 49 x 26cm
Foundry: Parellada, Barcelona
Joan Miró Foundation, Barcelona

20 *Tightrope Walker, 1969*
92 x 36 x 21cm
Foundry: Parellada, Barcelona
Joan Miró Foundation, Barcelona

21 *Woman, 1969*
73 x 41 x 36.5cm
Foundry: T Clémenti, Paris
Joan Miró Foundation, Barcelona

22 *Woman, 1969*
 42 x 12 x 10cm
 Foundry: Parellada, Barcelona
 Joan Miró Foundation, Barcelona

23 *Maternity, 1969*
 77 x 43 x 32cm
 Foundry: Parellada, Barcelona
 Joan Miró Foundation, Barcelona

24 *Woman Singing, 1970*
 84.5 x 75 x 30cm
 Foundry: Parellada, Barcelona
 Joan Miró Foundation, Barcelona

25 *Silent Constellation, 1970*
 68.5 x 34 x 15cm
 Foundry: T Clémenti, Paris
 Joan Miró Foundation, Barcelona

26 *Woman, 1970*
 60 x 27 x 16cm
 Foundry: Parellada, Barcelona
 Joan Miró Foundation, Barcelona

27 *Woman, 1970*
 55.5 x 29 x 10.5cm
 Foundry: Parellada, Barcelona
 Joan Miró Foundation, Barcelona

28 *Personage, 1970*
 109 x 38 x 28.5cm
 Foundry: Parellada, Barcelona
 Joan Miró Foundation, Barcelona

29 *Woman, 1971*
 63.5 x 27 x 35.5cm
 Foundry: Parellada, Barcelona
 Fabian Carlsson Gallery, London

30 *Personage, 1971*
 121 x 67 x 42cm
 Foundry: Parellada, Barcelona
 Joan Miró Foundation, Barcelona

31 *Bas relief, 1971*
 85.5 x 59.5 x 28cm
 Foundry: Parellada, Barcelona
 Joan Miró Foundation, Barcelona

32 *The Escape Ladder, 1971*
 81 x 29 x 18cm
 Foundry: Parellada, Barcelona
 Joan Miró Foundation, Barcelona

33 *Personage, 1972*
 51.5 x 21 x 14.5cm
 Foundry: Scuderí, Paris
 Fabian Carlsson Gallery, London

34 *Sculpture, 1973*
 36 x 19 x 10cm
 Foundry: Parellada, Barcelona
 Fabian Carlsson Gallery, London

35 *Personage, 1973*
 44 x 33 x 33cm
 Foundry: Parellada, Barcelona
 Fabian Carlsson Gallery, London

36 *Head, 1982*
 35.5 x 31.8 x 35.5cm
 Foundry: Susse, Paris
 Fabian Carlsson Gallery, London

37 *Personage, 1981 – 3*
 59 x 23 x 24cm
 Foundry: Parellada, Barcelona
 Fabian Carlsson Gallery, London

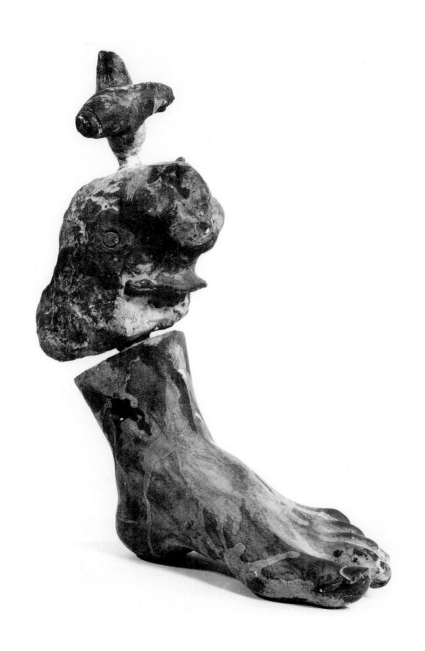

Personage and Bird, 1967
Cat no 9
Joan Miró Foundation,
Barcelona

Further Reading

DUPIN, J. *Joan Miró, Life and Work*, Thames and Hudson, London 1962

FONDATION MAEGHT *Miró – Peintures, Sculptures, Dessins, Céramiques 1956–1979*

FUNDACIÓ JOAN MIRÓ *Obra de Joan Miró* Barcelona 1988

JOUFFROY, A. & TEIXIDOR, J. *Miró Sculptures*, Maeght, Paris 1973

MOURE, G. *Miró Escultor*, Ministero de Cultura, Madrid 1986

PENROSE, R. *Miró*, Thames & Hudson, London 1970

ed ROWELL, M. *Joan Miró*, Selected Writings and Interviews, Thames & Hudson, London 1987

ed SEKULES, V. *The Touch of Dreams, Joan Miró Ceramics and Bronzes, 1949–1980*, Sainsbury Centre for Visual Arts 1985

SWANSON, D. 'The Artist's comments' in *Miró Sculptures*, Walker Art Centre, Minneapolis 1971

SYLVESTER, D. "About Miró's Sculpture", in *Miró Bronzes*, Hayward Gallery, ACGB 1972

Exhibition organised by Alexandra Noble
assisted by Richard Halstead

© The South Bank Board 1989

Reproduction of works by Joan Miró are
© ADAGP, Paris and DACS, London 1989

ISBN 1 85332 050 1

Catalogue designed by John Chippindale
assisted by Pamela Aldridge

Typesetting by Setwell, Shoreham-by-Sea
Printed by E.G.A. Partnership, Brighton

A full list of Arts Council & South Bank Centre
publications may be obtained from:
The Publications Office
South Bank Centre
Royal Festival Hall
Belvedere Road
London SE1 8XX

THE
SOUTH
BANK
CENTRE